Rosemary Sassoon

LETTERING

from formal to informal –
a journey with pen and brush

First published in Great Britain in 2009
A&C Black Publishers
36 Soho Square
London W1D 3QY
www.acblack.com

ISBN: 978 1 4081 1267 0

A CIP record for this book is available from the British Library.

Book design by Blacker Design

Printed and bound in Singapore

This book is produced using paper that is made
from wood grown in managed, sustainable
forests. It is natural, renewable and recyclable.
The logging and manufacturing processes
conform to the environmental regulations of
the country of origin.

Contents

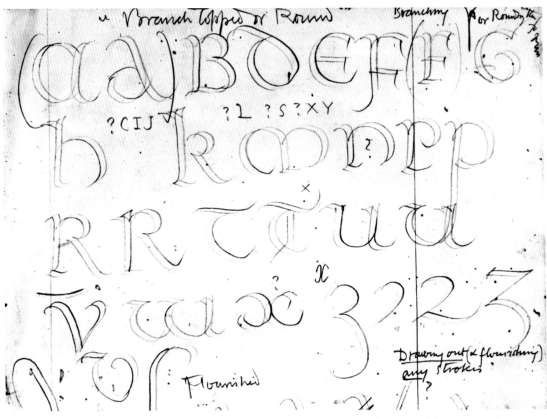

Uncial letters written with double pencils by Edward Johnston. From Dorothy Mahoney's notebook.

Below an uncial alphabet written for Gertrude Waley, one of Johnston's students, in 1929.

ABCDEFGhIJKLMNOPQ
RSTUVWXYZ abcdefghijk
lmnopqrstuvwxyz

Introduction

After over sixty years of being involved in letterforms it is inevitable that both my own attitudes and those in the outside world would have altered. From a strict classical beginning I have come to enjoy, value and teach, a more personal and creative kind of lettering. To do that I had to evolve quite new teaching methods.

Do not expect all the examples of lettering in this book to be perfect. It is meant to give readers ideas both on how to teach and for individual work – from pen lettering to the first stages of type design. I never managed to be a full time letterer, after my interest was aroused at school in my early teens. A year at art school was all I had in the uncertain days just after the Second World War. Afterwards when I was an apprentice in a traditional textile design studio I was lucky enough to study part-time with the master scribe M C Oliver.

After three years all this ended and I took a full time job as a packaging designer. This meant learning and using a different kind of lettering altogether. From then onwards my calligraphy, as it was called by then, had to be a part time, though no less important, part of my life. My commissions were seldom prestigious, just the every day jobs that scribes undertook when their occupation was still a useful and living craft.

This book charts my progression throughout the years from formal to informal letters, illustrated by whatever examples I have managed to save. Inevitably some of those from my early years have appeared in previous publications. In addtion I have found some archival material that had been hidden away and long forgotten, So there are also historical examples as guidance all the way to the inventive modern work by students at home and overseas.

I never expected to be a teacher, a writer or type designer, for that matter, but that is where a fascination with letterforms and design has led me. Later on in life my satisfaction has been in sharing this enthusiasm with others in many different walks of life and in different parts of the world. On the way I have probably learned as much as the students that I have taught.

the quick brown fox jumps jumps over the lazy lazy dog.

abccdefghij klmnopqrsstuvwxyz

CARGOES

Fours ¼ to 4 nib widths

rabcdefghijklmnopqrrstuvw
xyz & ?! "Foundational Hand"
1234567789o;rarryfl redx (-) æe.
ABCDEFGHIJKLMNOPQ
RSTUVWXYZ · EGNTY
abcdefghijklmnopqrstuvwxyz & 1234567890 *An Italic hand with Capitals*
ABCDEFGHIJKLMNOPQRSTUVWXYZ. *M.C. Oliver. Scripsit '47.*
To be used only for Initials
Sheet No 4
Chelsea Polytechnic London. SW3.

Examples of M C Oliver's lettering and his Foundational Hand exemplar sheet which we all used in our training.

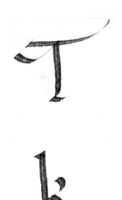

My real training as a letterer started under the master scribe M C Oliver, although I had been interested since the age of thirteen and continued learning during a year at art school. All day Monday and every Saturday morning I travelled to north London where Mr Oliver presided over his classes at Hampstead Gardens Institute, near where he lived. With Mr Oliver we had to unlearn all our bad habits and practise until we could replicate our master's Foundational Hand model. This was achieved first by using double pencils before progressing to ink. We used his special brown ink, writing the large letters with a reed before slowly reducing the size and graduating to a broad metal nib. Finally we progressed to cutting ourselves a quill and grinding our own Chinese stick ink.

All the teaching was on a one-to-one basis. Mr Oliver sat with students and made suggestions or corrections on each person's own paper with their own pen. Sharpness, freedom and liveliness were what we were told to aim for in our lettering, qualities that were always evident in his own work. This is evident even in his quickly written examples in the margins of our own pages of work, safely preserved for nearly 60 years. We were taught to take great care of our tools and to respect all forms of craftmanship.

Some of M C Oliver's letters

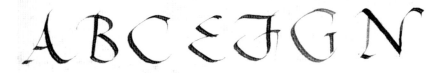

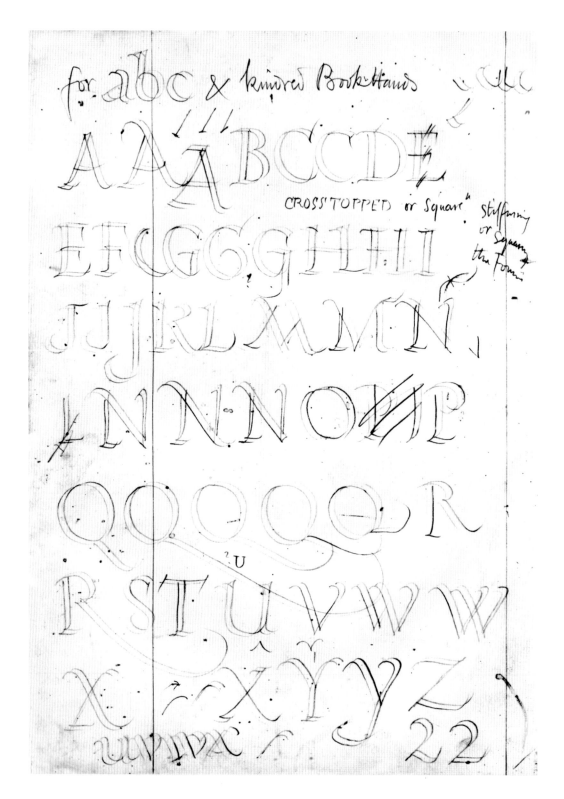

These two pages illustrate the double pencil technique that all students were taught to start with before being allowed to use pens and ink.

On the opposite page is an illustration of work by Edward Johnston. This photograph, and several other similar ones used throughout the book were given to me in 1980, with permission to reproduce them, by the late Dorothy Mahoney. She had been a student of Edward Johnston and succeeded him as tutor to the lettering class at the Royal College of Art. They appear in her book *The Craft of Calligraphy* published by Pelham Books in 1981 with the caption: 'Pages from my Johnston notebook'.

Below, the quick suggestion for a heading was done for me, a 16-year-old beginner, by Geoffrey Holden my lettering master at art school. He had first been taught by M C Oliver, who himself had come under Johnston's influence at the Royal College, and then by Dorothy Mahoney also at the Royal College. These first pages are rather like a family tree of lettering.

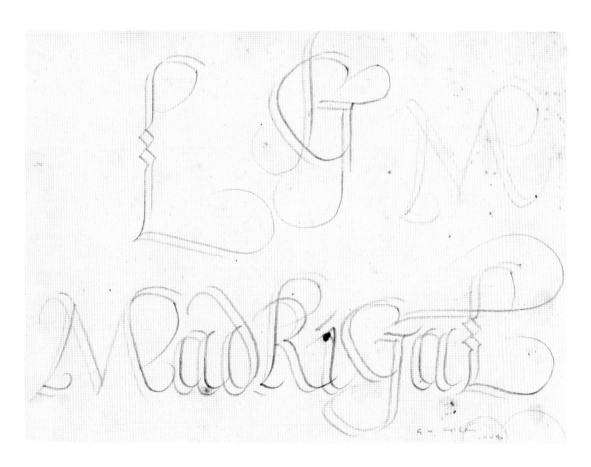

Full fathom five thy father lies
Of his bones are corals made
Those are pearls that were his eyes
Nothing of him that doth fade
But do suffer a sea change
Into something rich and strange
Sea nymphs hourly ring his knell
Hark now I do hear them
Ding, dong bell

are

Same size

something rich

The next stage for students was practice with a reed pen. I have four almost identical copies of this Shakespeare poem reminding me how conscientiously we practised. As soon as we were judged to be of an acceptable standard the pen size was reduced.

Below, these words which were probably written a few weeks later, show more flow and freedom.

light, cloth under

embroidered dark

falling forward

Full fathom five thy father lies

below the line *below the line* *too close*

Of his bones are corals made

too close *poor join* *slanting* *too close*

Those are pearls that were his eyes

below the line *too angled* *base too small* *sloping forward* *too close*

Nothing of him that doth fade

too close *below line* *too angled* *narrow*

hair lines exaggerated

But do suffer a sea change

narrow *too angled*

Into something rich and strange

slightly too close *this is the best written line*

Sea nymphs hourly ring his knell

too angled *poor join* *too close & narrow* *wide* *too close*

Hark now I do hear them

small base *cramped & heavy* *too angled* *sloping forward*

short

Ding, dong bell

too angled *sloping*

We were taught how to look closely into our letters and analyse our faults.

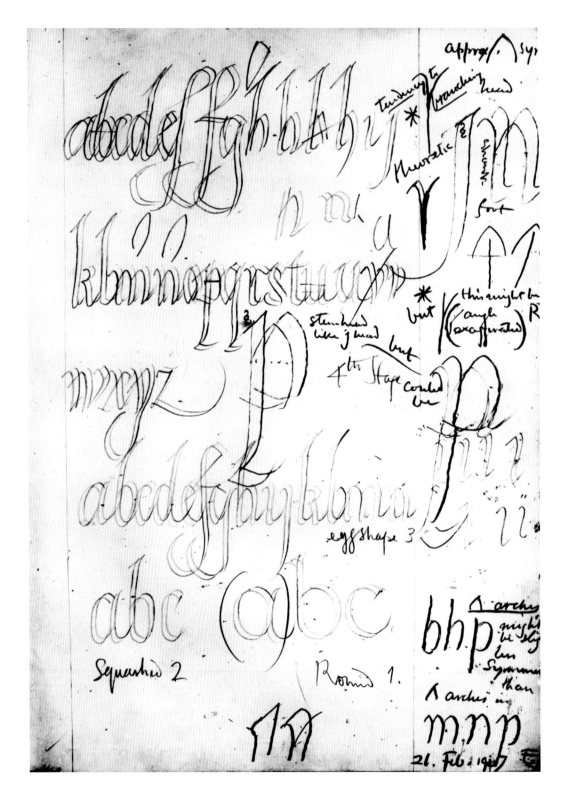

Translated **Aucassin & Nicolete** from a G
Anonymous Provençal Ballad. R. Waley scripsit 1950

Who would list to the good lay
Gladness of the captive grey?
'Tis how two young lovers met,
Aucassin and Nicolete.
Of the pains the Lover bore
And the sorrows he outwore,
For the goodness and the grace,
Of his love so fair of face

Sweet the song, the story sweet,
There is no man hearkens it,
No man living 'neath the sun,
So outwearied, so foredone,
Sick and woful, worn and sad,
But is healed, but is glad
'Tis so sweet.
So say they, speak they, tell they the tale

Of his love

Opposite, Johnston's
pointed italic from
Dorothy Mahoney's
notebook.

The next alphabet we
learned was the pointed
italic. Then it was time
for concentrating on
layouts combining
different hands and the
use of colour. Red
always had to be from
tubes of scarlet
vermilion watercolour.

We also were taught a
small informal italic.

abcdefghijklmnopqrstuvwxyz

A B C D E F G H I J K L M N O
P Q R S T U V W X Y Z &

minimum mvmwmxmymzmsmfmt
momcmemamgmbmdmpmg

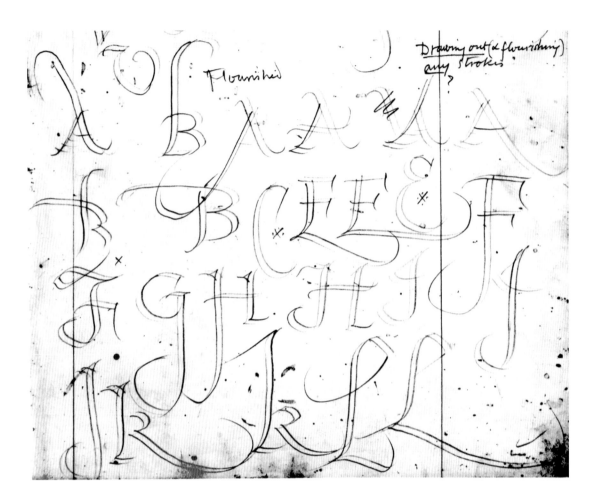

Some of Johnston's flourished capital letters again from Dorothy Mahoney's notebook and below some decorative ampersands by M C Oliver.

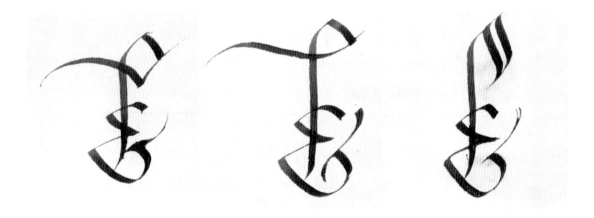

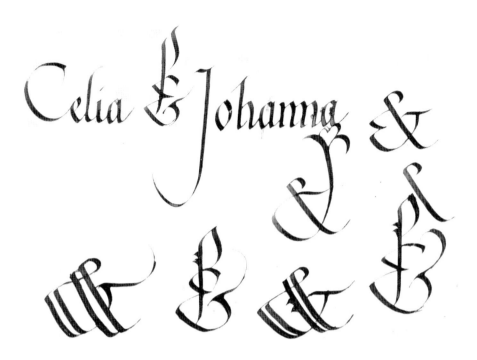

Some more of Oliver's letters that he penned to demonstrate in the margins of our pages as we worked. Below, are his sketches of a mongram and my solution.

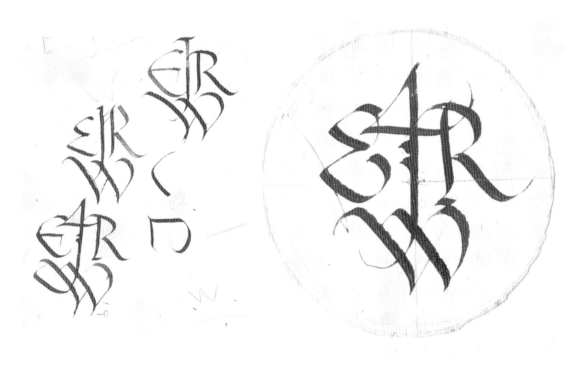

The Green-sailed Vessel

The Green-sailed Vessel

We are like doves. well-paired.
Veering across a meadow—
Children's voices below.
Their song and echo:

Like raven. wren or crow
That cry and prophesy.
What do we not foreknow.
Whether deep or shallow?

Like the tiller and prow
Of a green-sailed vessel
Voyaging. none knows how.
Between moon and shadow:

Like the restless. endless
Blossoming of a bough.
Like tansy. violet. mallow.
Like the sun's afterglow.

Of sharp resemblances
What further must I show
Until your black eyes narrow.
Furrowing your clear brow?

These two pages illustrate typical commissions undertaken during the following years. I never made a photographic record of completed jobs, so all the lettering shown here comes from the few fragments of rough copies that I kept.

The Green Sailed Vessel by Robert Graves was a presentation given to him by his literary agent. The final copy had an inscription underneath which made it more balanced. *The Turne* was a memorial for a child who died young. It includes the line, 'A lillie of a day is fairer farre in May'.

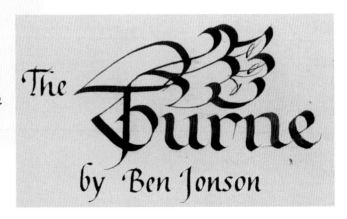

The Turne
by Ben Jonson

16

Le Conseil Municipal d'Edenbridge

There were always plenty of civic jobs to do like this town-twinning presentation in French.

Your Royal Highness

There were several loyal addresses around the time of the Coronation.

The Charter

This large charter reminds me of the pressure under which I worked. Councils seldom gave me more than a couple of days notice and expected that it was no more work than typesetting. This large piece was wanted so quickly that there was only time to work out the heading and do this scribbled layout before doing the finished job.

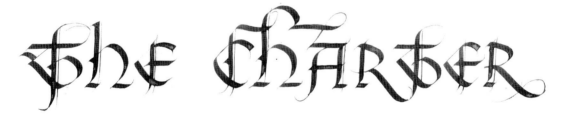

Copperplate was much more difficult to master. This can be seen from a sheet practising just one word. It was a heading for a poem by John Clare about hawks. It was destined for an English textbook. It was useful to have done some Copperplate, when it came to the Lewis Carroll Exhibition.

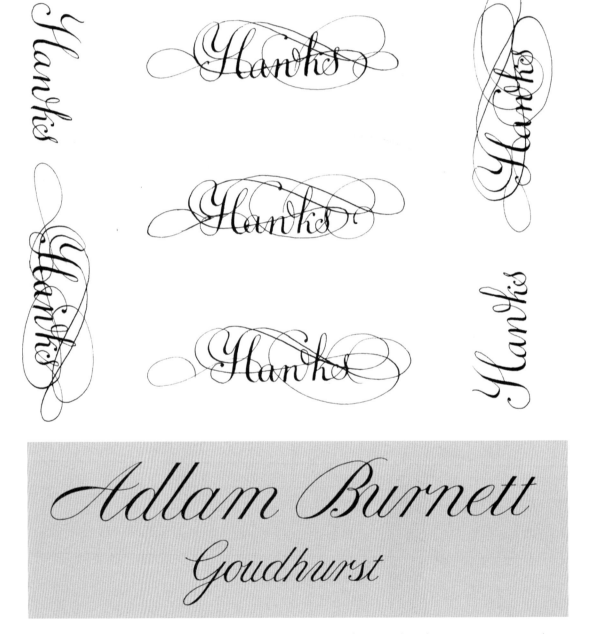

This name plate, for the makers of keyboard instruments, in drawn, rather than written, Copperplate.

From time to time I learned other hands either out of interest or necessity. These decorative capital letters by Geofrey Tory, from Champs Fleury, 1529, had always attracted me and seemed appropriate when someone wanted designs for honey labels. Being more or less contemporary with Caxton, some of Tory's other alphabets were a useful starting point for the simplified letters used in the exhibition shown on p33.

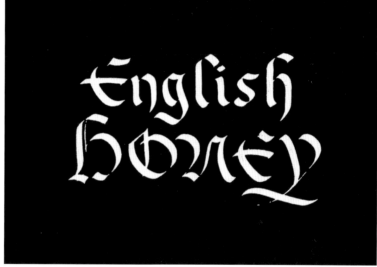

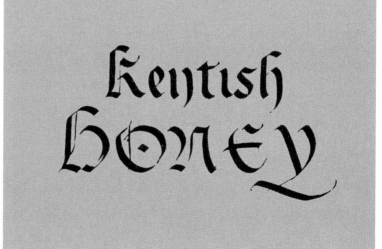

Part 2 **Commercial lettering**

When the textile studio where I had worked for three years suddenly closed I needed a job. The advertisement that I answered read: 'Wanted a designer with studio experience who is good at lettering.' It was a packaging studio and the lettering was very different from anything that I had done before, but it was a challenge.

There was an abundance of good brush and drawn lettering available in the 1950s. These are some examples from my scrapbooks from that time.

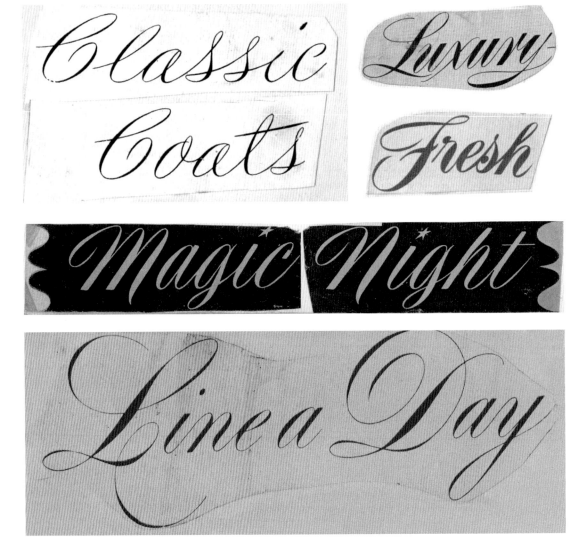

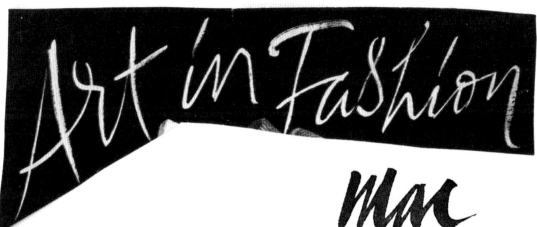

Mac
Fish-
fresh
Fish

My favourites are the Mac
Fishery lettering and
packaging illustrations.

Cleaner, Fresher
Complexion

Faites comme moi, exigez

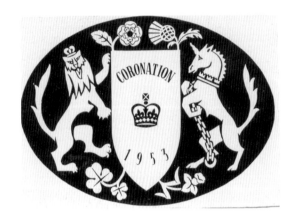

Sometimes there were opportunities for me to use more traditional lettering but most of the time it was a matter of learning commercial styles.

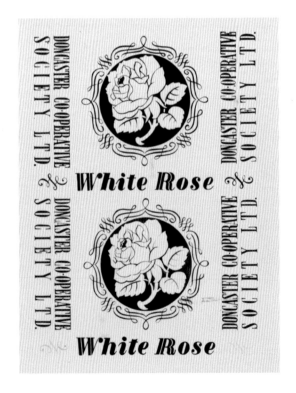

These sketches have somehow survived more than fifty years, and are typical of my everyday work in the packaging studio.

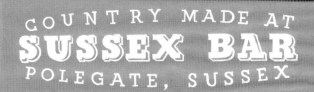

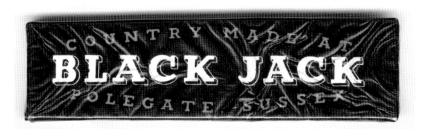

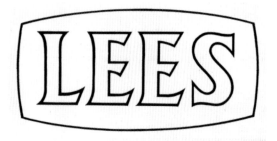

All types of lettering,
drawn and brush,
were part of our
everyday work.

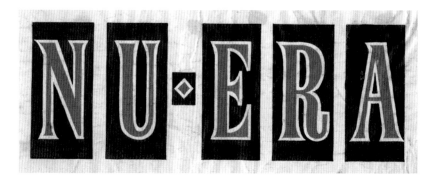

Designing bread wrappers could be more interesting than you might think. I cannot guarantee, after fifty years, that these original designs were mine. I can remember, however, meticulously doing the airbrushed roses which looked just like a pink blob when printed.

Part 3 Lettering as decorative art and other uses

From CANDY CHERRIES 1668

To CANDY CHERRIES

A Queen's Delight of Conserves & Preserves

Take of these fruits and strew fine sifted sugar upon
them as you do flower on frying fish. Lay them on a
lettice of wier in a deep earthen pan & put in an oven
as hot as for manchet, then take them out, turn & sugar
them again & sprinkle a little Rosewater on them. Pour the
syrup forth as it comes from them, thus turning and sugar-
ing till they be allmost dry. Take them out of the pan
& lay the lettice upon two billets of wood in a warm oven
after the bread is drawn, till they be dry & well candied.

To Make Wafers

From the Receipt Book of John Nott. 1723

Put the yolks of four eggs and three spoonfulls of Rosewater to a
quart of flour. Mingle them well, make them into a batter with cream
and double refined Sugar. Pour it on very thin & bake it on irons.

The idea of using lettering as a decorative art came about because of
an exhibition. It concerned products to sell to foreign tourists and was
severely criticised. Here was a new opportunity, but it was something else
as well. Calligraphy and hand lettering had almost disappeared from the
public view by the end of the '60s, and this was a chance to bring it back.
At first I produced original pieces for specialist shops. It soon became
obvious that reproducing work on various materials was the way forward.

A series of calendars was produced by J Salmon Ltd for five years. The order was never confirmed until a couple of weeks before finished drawings were needed. There was always a rush to find suitable material, so that left little time for roughs.

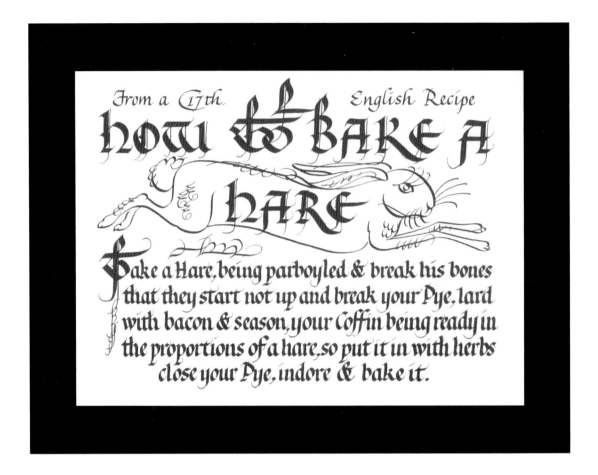

This is one of a set of eight mats designed for Harrods. Part of the pleasure of this work was the preliminary research for material undertaken in the British Library. In those days we were allowed to handle the original 16th- and 17th-century recipe books and herbals. These pages show the effective use of broad edged pen drawings to accompany lettering.

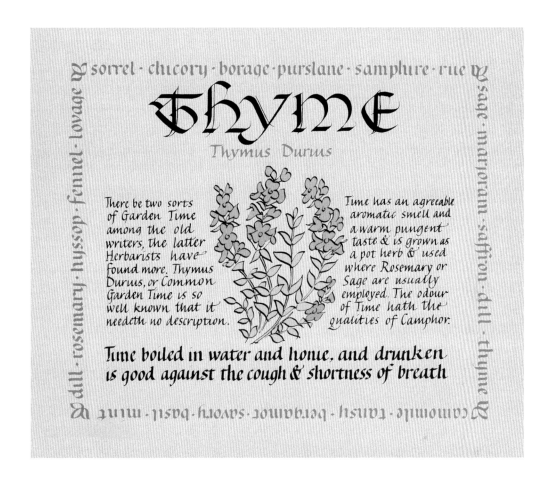

This is from a set of eight mats for a firm called Culpeper. I got the idea of using small informal lettering surrounding the illustrations from one of the herbals.

Suddenly everyone seemed to want calligraphic designs on various materials. As well as mats there were circular tin trays, tea towels, postcards for sale in stately homes and paper packaging. These mat designs made for John Lewis are my favourites. These three were the smaller of two sizes.

Today it would be easy to do something similar – just do one element then scan and repeat. Then it meant rotating the paper as you worked each segment around the circle.

Opposite: a repeating design for wrapping paper for Brown, Knight and Truscott.

Same size motif for one of the larger mats.

TO ROAST A PIGGE
From an Elizabethan recipe

Take your Pigge and draw it, wash it cleane and take out the liver. Perboile it and straine it with a little creame and yolkes of egges, put these to grated bread, marrow and small raisons, nutmegs in powder, mace, ginger & salt, sturre all these together, put into the Pigges bellye, sowe it then spit it with the haire on. When it is halfe enough pull off the skinne, baste it, and when it is enough crumb it with white bread, sugar, sinamon and ginger, let it be somewhat browne and so serve it.

Your Crabs being boyled, take the meat out of the bodies and barrels and save the great claws and small legs whole to garnish your dish. Strain the meat with some Claret wine, grated Bread, Mace, Nutmeg, Salt and Butter, stew them together for one quarter of an hour on a soft fire in a Pipkin, and being stewed almost dry, put in an egg yolk with the juice of several Oranges, beat up thick, and put the meat in shells. Dish the legs round about & serve.

To make A PARTRIDGE TART
from a 17th century recipe

Take the flesh of four or five Partridges and mince them very fine with the same weight of Beef marrow as you have of Partridge flesh, two ounces of Orangeadoes & green Citron minced together as small as your meat, and season with Cloves, Mace, Nutmeg, a little Salt and Sugar. Mix them all together and bake in a Puffe Paste. When it is baked, put in half a graine of Muske or Amber brayed in a Morter or Dishe and a spoonful of Rosewater & Orange juice and so serve it up

TO SEETHE A CARPE
From a 17th Century Recipe

Fyrste take a Carpe, boile it in water & salt then take of the broth, put in a pot and put thereto as much wine as there is broth, with Rosemary, Parslie, Time, Marjoram, bounde together, put thereto as much of sliced onyons, small raisons whole Maces, a dishe of butter and a little sugar so that it be not too sharpe or too sweete, and let all these seethe together. If the wine be not sharpe enough then put thereto a little vinegar. And so serve it upon soppes with the brothe.

TO STEW CRABS

A stage designer friend had the idea of using hand lettering for the legend and other purposes for travelling exhibitions. The first was for the Lewis Carroll Society. For the large panels, which were wanted in a hurry, Copperplate was not practical, so a fast semi-cursive italic was used. There were also small framed quotations in carefully written Copperplate. They were all eventually stolen, so they must have convinced some of the public that they were original and valuable!

Victorian kitchens were mostly underground, dark and smoky, where huge quantities of meat were cooked, some of which went bad and had to be highly seasoned with pepper. Cooks were therefore often very bad-tempered. Alice and Lewis Carroll knew kitchens and cooks like this and so Carroll made Alice find one in her dream.

Because it was a dream it contained, besides bad meat and a cross cook, a baby that turned into a pig and a cat that turned into a grin and a huge tin of treacle that turned into a well with three little girls living in it. These three little girls are Alice Liddell and her two sisters. They are also part of a story told by the dormouse at the Mad Hatter's Tea Party next door. This tea party had no beginning and no end.

Alice

This tea party had no end.

The White Knight
Alice thought she had never seen such a strange-looking soldier in all her life

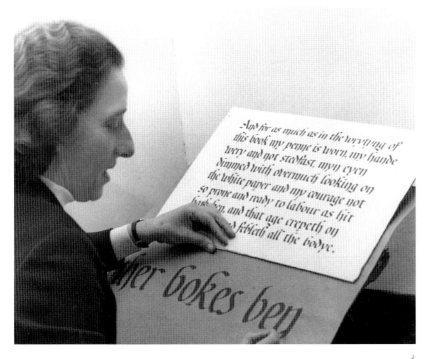

Next came an exhibition commemorating Caxton and 500 years of printing in England. It travelled widely and each time the notices needed to be altered. In Belgium everything had to be translated into Flemish.

The author working on letters that had two purposes: to add atmosphere while providing a bridge to help the audience decipher original documents in Caxton's own typefaces. These were based partly on his own handwriting.

Part 4 A simplified method for adult education

When I was asked to start the first adult education classes in our part of England in 1979, I had no idea of what to expect. It soon became obvious that a much simpler method of teaching was needed. Everything needed to be broken down into manageable stages. Patterns were first used to learn to keep the pen at a constant angle. Then came double pencil exercises with the alphabet divided into stroke related families, before embarking on pen and ink. Nearly all instruction was on a one-to-one basis. Even at the start, there was considerable variation in skill between individuals. My model alphabets were kept relatively simple to appear accessible for beginners.

 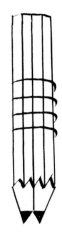

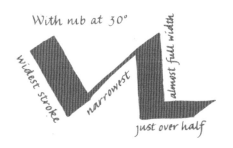

This diagram illustrates the relative width of strokes when the pen is held at 30 degrees.

Exercises to help students keep double pencils or pen at the correct angle.

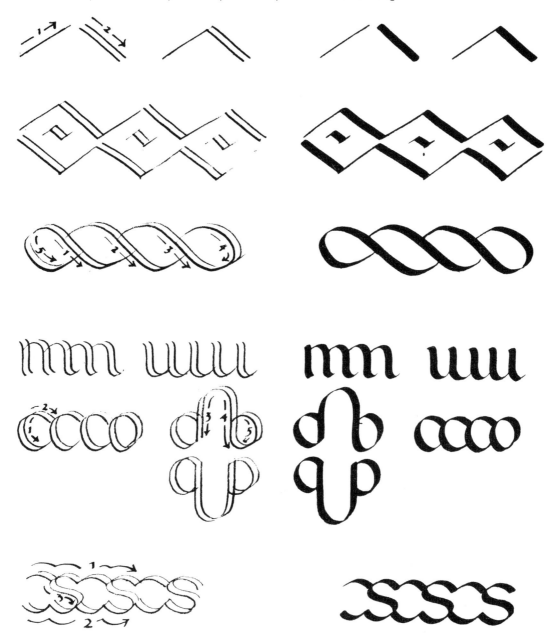

I suggested starting with letters in their simplest form divided into stroke-related sequences

The first group should consist of letters constructed with straight lines and arches.

iljnmrhu

minimum

The second group consists of letters that include rounded strokes.

ocebdpq

cope bode

The third group consists of more complex letters and those with diagonal strokes.

agkftz

svwxy

Simplified versions of **a g** and **y**.

agy

Details and terminals, illustrated separately to help beginners. First of all serifs. They are written in three separate strokes. The top of the **t** is also written in three strokes.

Upright strokes that are followed by a curve start with a slight push outwards. Start the second stroke at the outer edge of the upright.

Diagonal strokes start with a slight swing. The second stroke starts with a separate horizontal stroke.

The bases of **f**, **k**, **q** and **p** as well as are written in two separate strokes.

Other bases are formed by a swing at the end of the upright.

Notice the point of the **v** and how two curved strokes join.

Small foundational letters written with
double pencil.

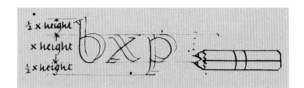

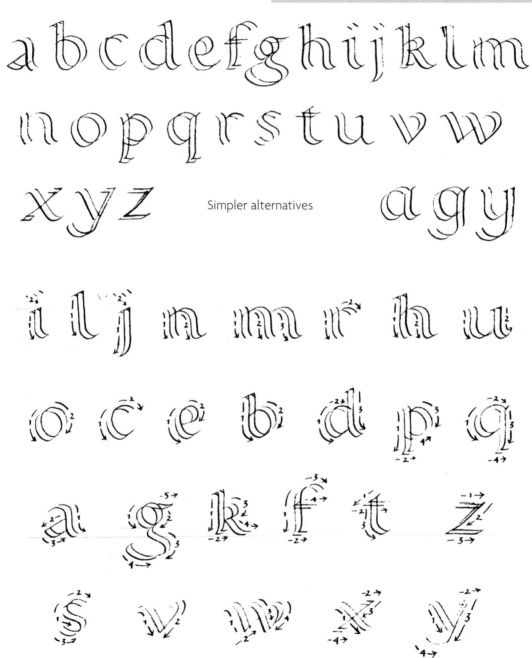

Simpler alternatives

start

large

as you im-

prove reduce

the size by paring

more from inside

both pencils

All alphabets, formal or informal, are best learned in stroke-related sequences.
With the compressed alphabet it is sometimes difficult to be consistent.
These sequences are a particular help with this hand.

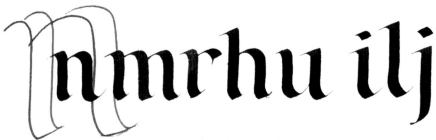

These letters show how much to compress.

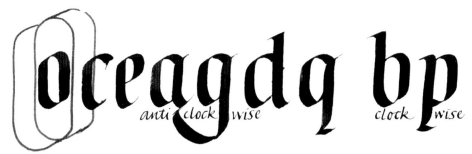

These letters show how to flatten the sides.

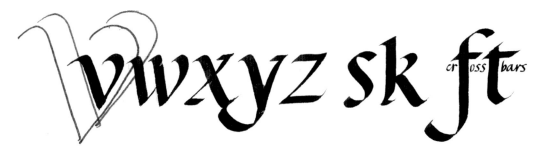

The angle of oblique strokes needs to be changed.

Compare the different weight and shape, axis and angle of arches and **o**s plus the changing angle of the diagonal strokes in:

1 Foundational
2 Compressed
3 Formal italic
4 Gothic hand

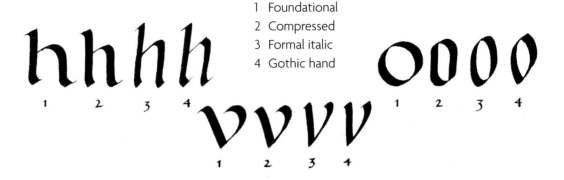

Formal italic sequences.
Notice that the pen is held at a different angle.

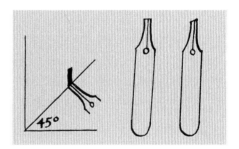

The arch branches from halfway up the stem of the letter.

Versals are capital letters built up with a pen. Use a fairly narrow nib to outline the letters, giving the uprights a slightly waisted appearance. Use the full width of the pen for the double strokes and then flood the letters with a final firm stroke of the pen.

A B C D E F G H

Wide letters: **O C D G Q M W**. Medium letters: **H U A N** and **T V**.

I J K L M N O P

Narrow letters: **I J B E F K L P R S X Y** and **Z**

Q R S T U V W

X Y Z

Uncial forms.

ð e G h k τ ɯ

CIRCUMSCRIBING

All upright strokes must radiate from the centre of the circle

REVERSED

INFORMAL AND OPEN

Praise
In the
Open
Also
1

there
Even
the
before
2

that
One
at
how
3

Versals can be set:

1 Outside the text
2 Inside the text
3 Half in and half outside the text.

Initial letters can be given weight with a background of colour or pattern.

Use the inner edge of the nib when finishing a stroke, either downwards or freely up and over.

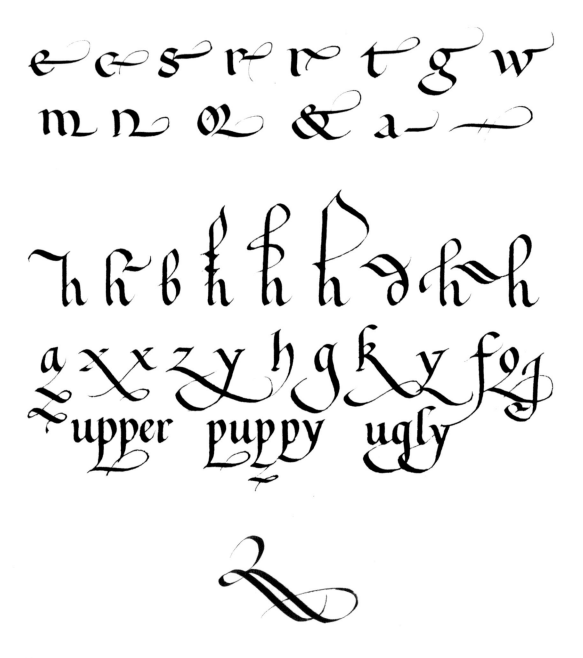

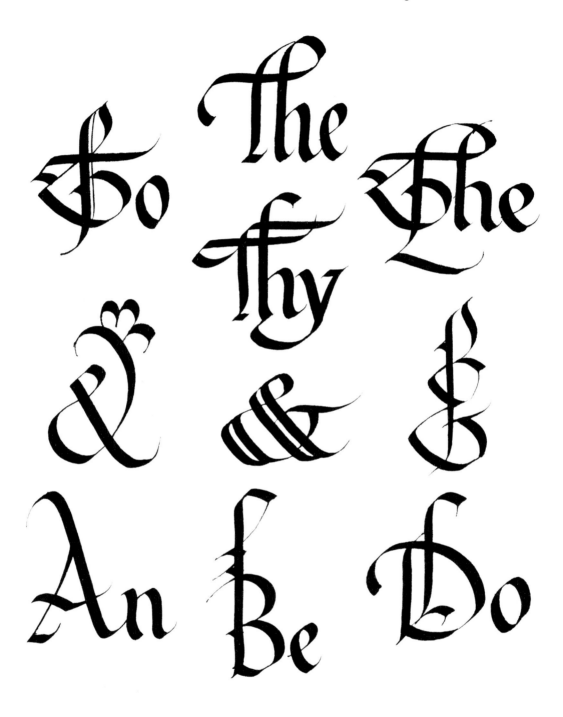

Flourishes fill in short lines, give height to headings and extend descenders. They should be used sparingly.

Christmas comes conveniently at the end of the first term which consists of ten two-hour sessions.

On this page are some of the rough ideas that I did to give the students a starting point.

Their examples, shown opposite, give a useful indication of how far they had progressed.

Opposite: some had started to experiment with letters quite successfully, while others were still keeping to their version of the Foundational Hand with mixed results. Others started to try out pen patterns. Unfortunately these examples were all that I could find.

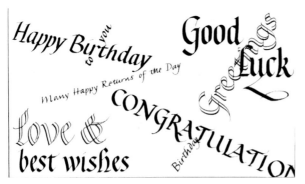

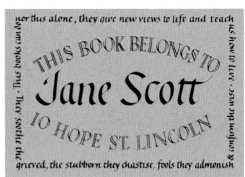

It then came time to show everyone how to combine the different alphabets. Some had progressed to italic, many to compressed letters. Informal versals were popular. These quick ideas of mine were to stimulate students to produce their own ideas. I only have a very blurred photograph of one of our exhibitions to remind me of the volume of work and different layouts they produced.

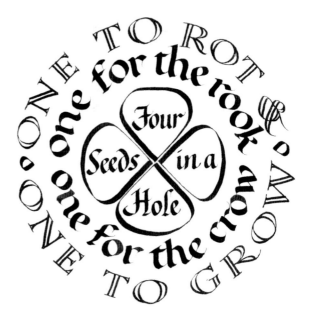

At times the content of my rough ideas were of as much interest to the classes as the lettering.

Some people saw my calligraphic mats and wanted to try something
similar, but even this fairly simple one was too difficult for many of them.

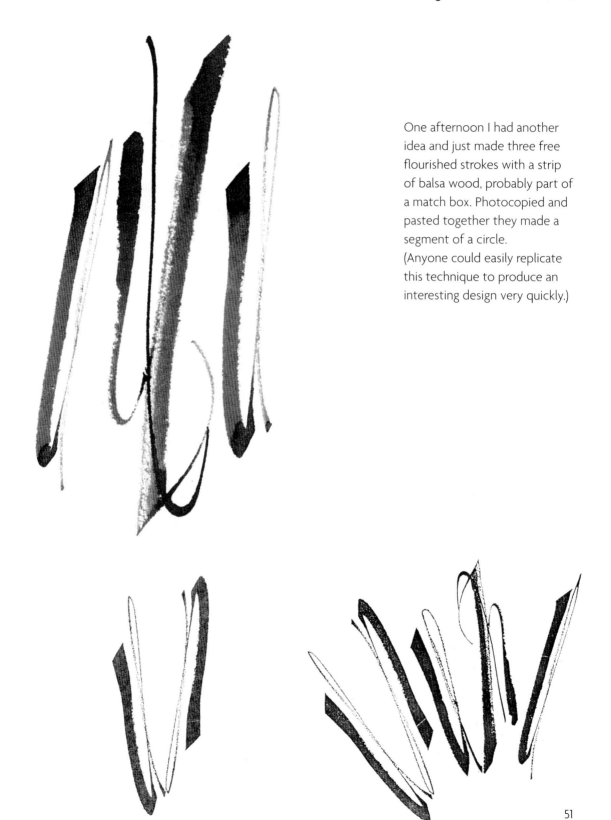

One afternoon I had another idea and just made three free flourished strokes with a strip of balsa wood, probably part of a match box. Photocopied and pasted together they made a segment of a circle.
(Anyone could easily replicate this technique to produce an interesting design very quickly.)

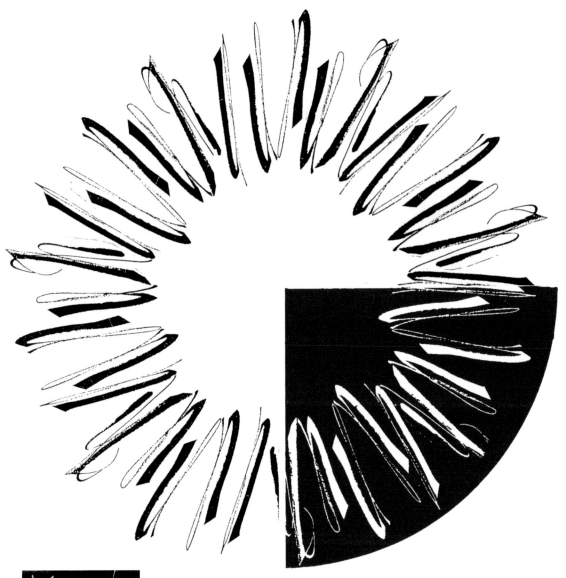

That way I made an effective roundel in just a few minutes. Then I realised they could make letters. The straight ones were easy.

It needed a few rounded flourishes as well to make a whole alphabet. The students had fun but I always wished that I had spent a bit more time myself on this project.

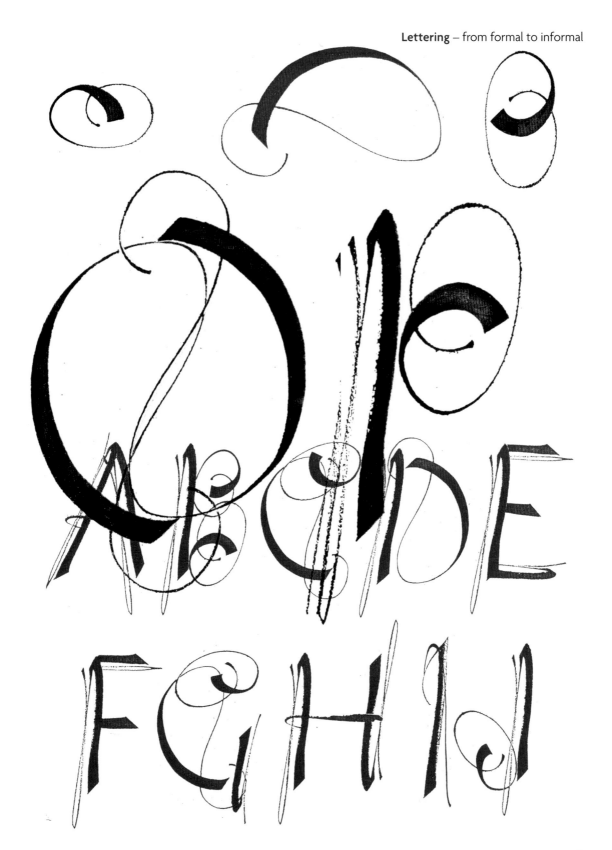

The broad edged pen is a wonderful tool but there comes a time when many people want to move on. The best way I have found is through the natural movement of their own handwriting. The first exercise is to join up an alphabet of capital letters. It is such an unusual thing to be asked to do, but it also revealing.

Timothy, a friend, had already embarked on a career as a letterer, when he visited us and demonstrated this exercise. You can see he had a natural italic hand.

A student who tried this found, quite unexpectedly, that she had a natural copperplate movement.

A student explores the decorative possibilites of her own handwriting. It looks better with a fatter pen.

It gets better and better.

tamra

tamra

tamra

tamra

tamra

tam

tam

It is time to break away from some more rules. First change the proportions of pen width to height. See what happened when Timothy's letters altered from tall and slim to short and fat.

When an inexperienced student tried the same exercise, her letters became more interesting as they became shorter and fatter.

diminish

diminish

diminish

diminish

diminish

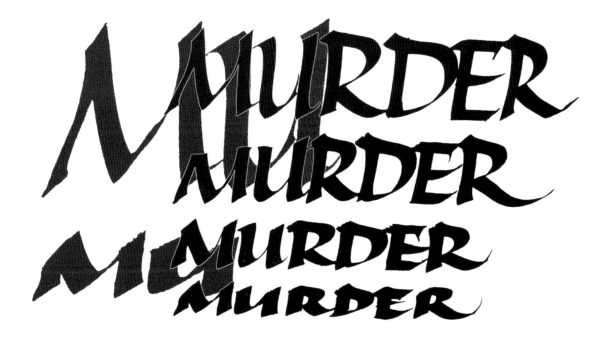

Here is the same treatment given to capital letters. Timothy's letters change from being fairly formal with interesting terminals to simple, but very decorative shapes with barely a pen lift. This exercise might be useful for many beginners whose capital letters tend to look rather weak and spindly. Just reduce the height and see what happens.

Below a student tries the same treatment with some more unconventional capital letters.

Changing the angle of the pen can produce dramatic letters such as Timothy's first effort at capital letters

This student turned her pen around so that the fattest stroke was horizontal. It made all the difference to her sketched logo for her dance studio.

A student's effort

abcdefghijklm ABCDEFGHI

Nebiolo, a typeface designed by Aldo Novarese, is designed with the same horizontal emphasis.

Reversing letters from black to white without outlining them is not easy, as Timothy found at first. These examples on the left illustrate the difficulties but he succeeded in the end with 'Caroline'.

A beginner, who found ordinary versals difficult, discovered that outlining them and leaving the letters white was effective.

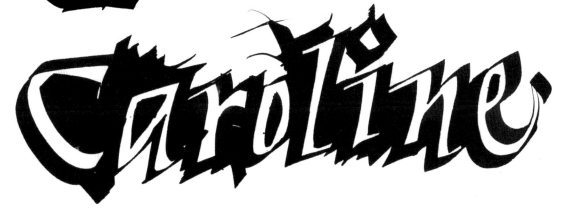

half an inch

Above: about the largest size letters you can produce with a metal nib. For larger lettering other implements must be explored.

Thin balsa wood cuts easily to make a large flexible writing tool. This **a** was written with a pen made from the side of a matchbox.

Carpenter's Pencil SOFT

Two felt or fibre-tipped pens can be strapped together and effectively used like double pencils for large display lettering.

Versals can be written fairly freely in any size with felt- or fibre-tipped pens. They can be filled in or left open.

Reduced

Double letters can be constructed even larger, using two strokes for thick lines and one for thin.

Brush Letters

Letterforms
of the
foundational hand

a Character Script

Complete freedom comes when you can control the brush and ink flow.
Brush lettering allows anyone to produce fast and effective notices.

Vary *in size* and shape

or Thick

thin

round and Square

Speed and Freedom are the advantages of brush scripts

Greetings

Sale
Sale
Sale
Sale
Sale
Sale
Today

Advertising

An
Announcement

This way of teaching allowed students choice, but there was more to it than exercises. I wanted to expose everyone to as many aspects of lettering as possible – from illuminated manuscripts and history, to cut and engraved letters, typography, modern packaging and advertising – all in the short time available. So, at the beginning of each session I would bring in something of interest to discuss and handle. It might be my battered 14th-century book of hours or beautiful wooden roundel carved by Will Carter. There were lovely old handwritten legal documents to be found cheaply in those days. They illustrated interesting letterforms as did old newspapers. At the other extreme I took in modern brush and drawn lettering from my own collection. The students were also encouraged to keep their own scrapbooks.

As they became more proficient I was able to pass on to students the various small commissions that came my way, mostly for charities and churches. The best way of progressing is through real jobs.

With such diverse groups, with students engaged in different projects, I taught in the same way that I had been taught. I went around the class teaching and correcting individuals at their own desk with their own pens on their own paper – encouraging the less able and pushing the more advanced students to the next level. After two or three years the head of the centre announced that this was a waste of valuable time and all instruction should be from the front of the class. He insisted that I attended his course and learned how to teach properly. It was time for me to leave.

Flowers

Congratulations

Part 5 Lettering in Australia

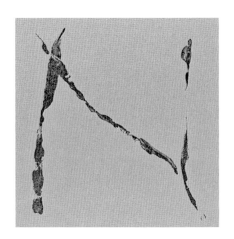

In the following years my own career took off in other directions, however, I continued teaching from time to time, mainly in Australia where I spend a couple of months each year. There I taught at many levels.

More challenging were the summer schools that took place mostly in isolated towns along Western Australia's great Southern Ocean. Here, farmers' wives and others mainly from the vast interior, came by custom for a break and new experiences. There were some serious students but most wanted letters and techniques that they could take home, using what equipment they could get to find satisfaction in a creative occupation. I have few examples from that period, but the lessons sometimes consisted of showing how different tools can produce effective letters, or how appearance can suggest meaning.

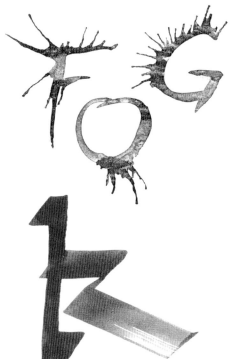

The lid of a screw-top jar was used to print out the letter **N** and paint was blown through a straw to produce the word 'fog'. A home-made balsa wood pen made this rather striking **k**, and the word 'square' was painted without drawing the letters first.

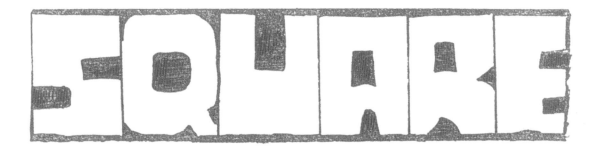

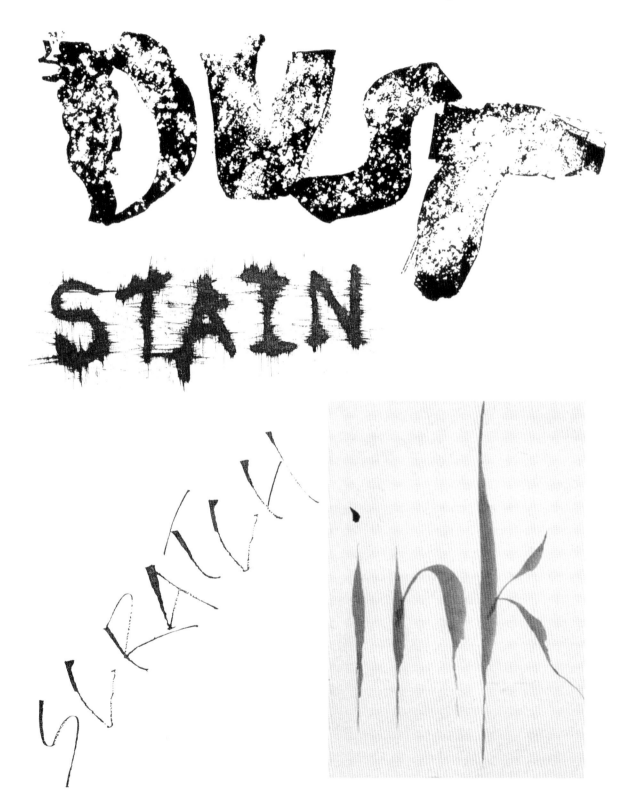

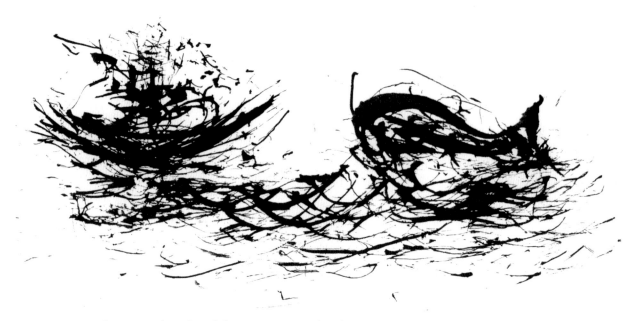

Here are a few examples of work from a summer school in Esperance, an old whaling port. One student used seaweed to illustrate her work 'Whaling in the old days'. Others used any material they could find outside. Sticks, stems, feathers, leaves, etc. all can be used to produce interesting letters.

 Charles Creighton was only ten when he asked to join an adult class and produced this alphabet working with a broad edged felt pen. The word 'Dust' on the previous page was also his work. He grated a piece of cuttle fish on to wet letters to get the desired effect.

(pine leaf)

When you look at this alphabet, a first attempt by young Charles Creighton, you must wonder where this unusual concept of letters comes from.

The examples in the next pages come from a short lettering course for first year design students at Curtin University, Perth, Western Australia. With only five mornings, the first one was structured to give a very brief introduction to traditional letters with double pencils and broad edged pens and then quickly on to freer forms. On the last morning, the students completed a finished piece of their own choosing, before staging an exhibition in the afternoon.

None of the students had any experience of letterforms. When it comes to the broad edged lettering this is an advantage. If someone has never tried this before then many people can be taught some good letterforms in a very short time. If they have experimented by themselves then they have to unlearn any bad habits before they can improve.

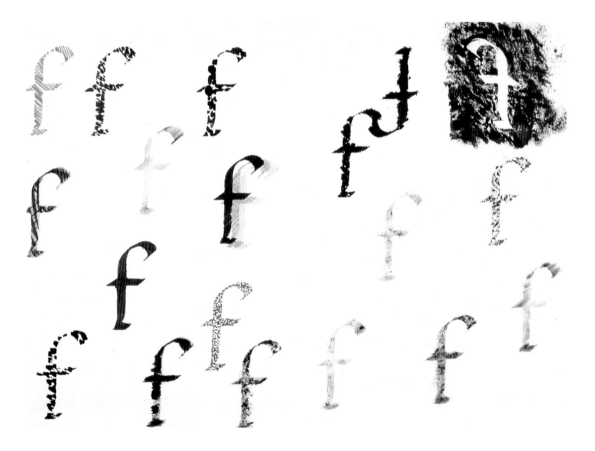

Students were encouraged to concentrate on just one or two letters to start with. Janet Stockdale showed how effective that could be with her page of **f**s. Students mastered the double pencils and pens quickly and went on to design monograms and repeat patterns. The work on this page is by Vanessa Rowe, Edwin Fong, Cecile Freudenthaller and Sonya Michael.

The same techniques that I developed for adult education, and are illustrated on page 55, were used again to encourage these students to produce free lettering based on their own personal handwriting. This shows everyone how easy it is to produce something original and striking. This group immediately started to discuss how they could use this in their graphics work.

Later, one student, Lucia Arena, mounted up much of her free lettering on one sheet, making an interesting pattern in itself. You can imagine something similar as a wrapping paper or even a textile design.

At the top of the next page Stuart Ringholt experimented overprinting on top of a panel of free writing.

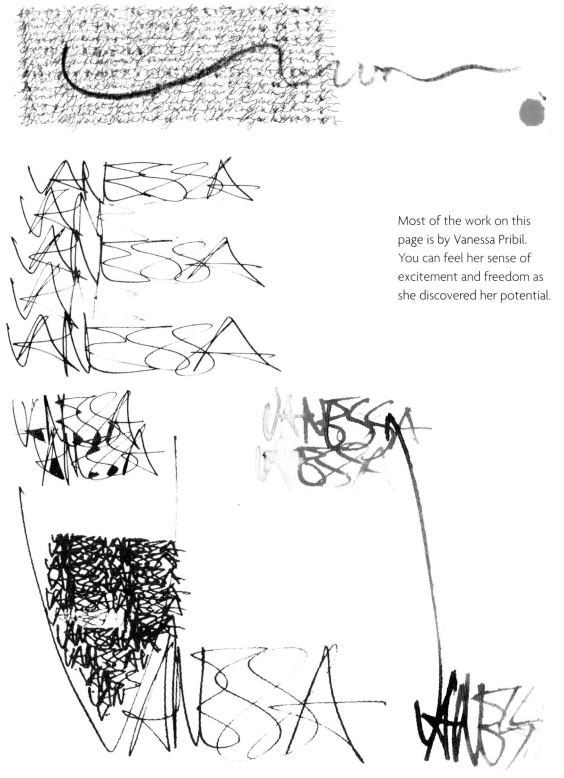

Most of the work on this page is by Vanessa Pribil. You can feel her sense of excitement and freedom as she discovered her potential.

These two pages show how Tracy Boughey went through several stages before developing her final simple monogram. Several years later, when asked what the course had meant for her, Tracy (now Graffin, and a professional designer) replied that it inspired an appreciation for hand-drawn type and opened up exciting possibilities of creating letterforms.

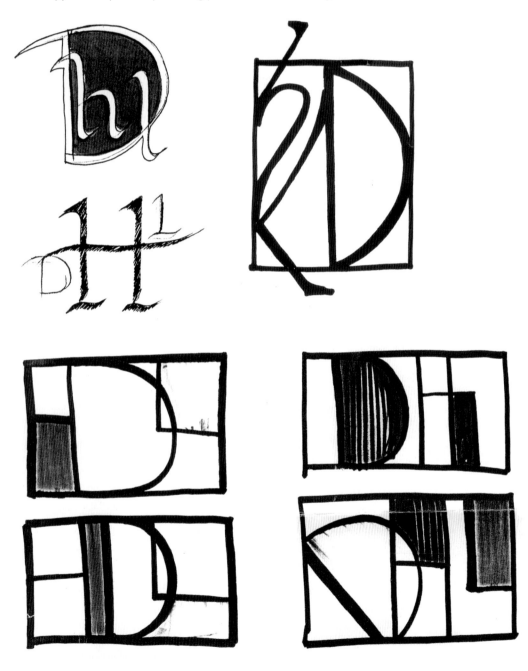

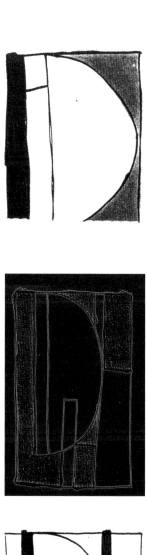

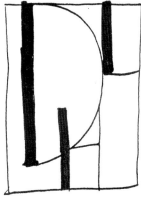

Sadly, many of the monograms and repeat patterns were unsigned so it is not possible to acknowledge the individual designers. It is always interesting to see how groups differ from one another, even when they are started off using the same exercises. This group was particularly fascinated by the use of pattern.

Only two students attempted more disciplined alphabets. The one below, by Nicole Grant, was interesting because she was left-handed. Her letterforms were influenced by the angle of her pen. Many left handers find it easier to use the pen so that the nib is straight rather than at an angle. These letters are a good example of that and gain originality from it.

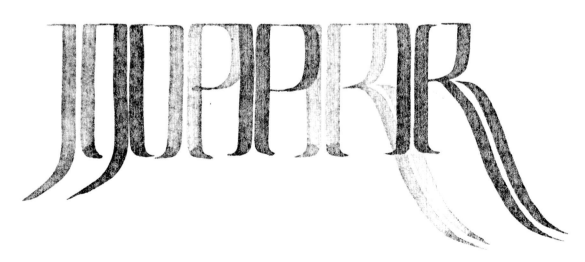

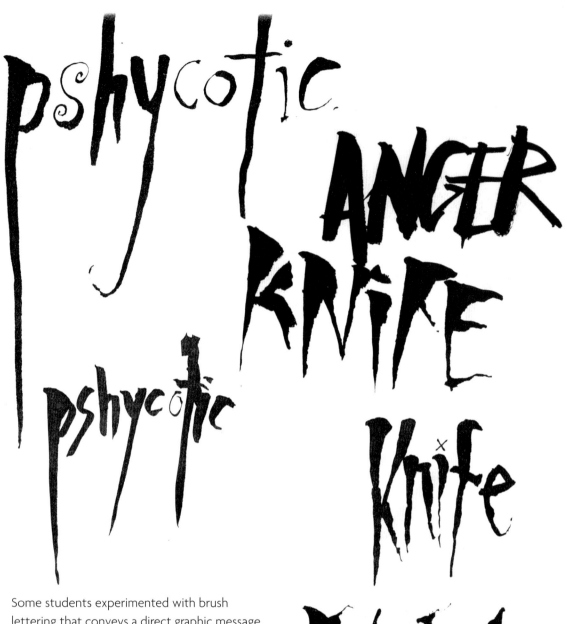

Some students experimented with brush lettering that conveys a direct graphic message and only needs confidence to express the meaning and mood of a word. You can always do several versions then cut and paste the best letters as professionals do to get the best results – or to correct the spelling!

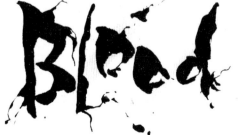

ABCDEFGHIJKLMNOPQRS
TUVWXYZ DEFINE JOG QUIZ

ABCDEFGHIJKLM
NOPQRSTUVWX
YZ DEAF JOG QUIZ

abcdefghijkl
mnopqrstuvwxyz
jog quiz

These three quick versions of a brush alphabet may look rough but when the most successful letters are isolated (in red) you can begin to see something interesting. The strong personal style that links the three alphabets could be developed into something positive using the most original forms. The rest of the set could be built up using similar strokes.

Two of the individual projects used ordinary handwriting in an unusual
way with great success. Stacy's use of her name as shading on the portrait
is outstanding, likewise the word 'hands' used opposite. Another student
just used 'words' to cover a large sheet.

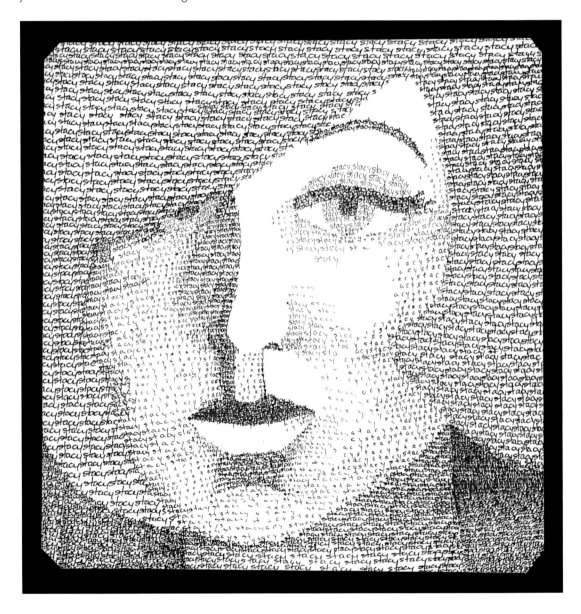

It is not often that I get any feedback after a workshop or course, but this time it was different. My association with Curtin began several years ago, when Paul Green-Armytage, senior lecturer and course controller for first year design students, attended a day of creative lettering. It was for experienced calligraphers and designers in Perth. He found it interesting and invited me to do something with his students. The results of that course appear on the previous pages and were judged so positive that Paul decided to replicate the course himself the following year. The work, some of which appears on the following pages, was impressive, particularly the complete alphabets. Remember, these are first year students with no previous experience of lettering.

Work by Brad Carpenter (below) and Dario Yussof.

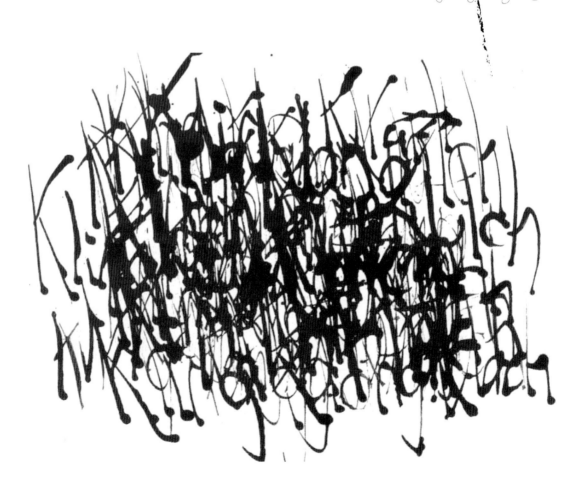

'HA HA' by Jason Yap, alphabet by
Nghi Nguyen and Simone Richards'
work below.

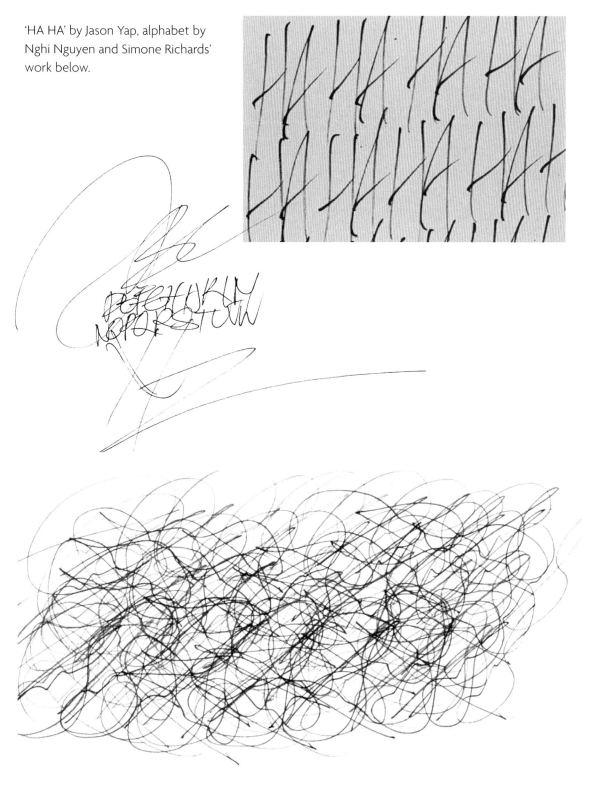

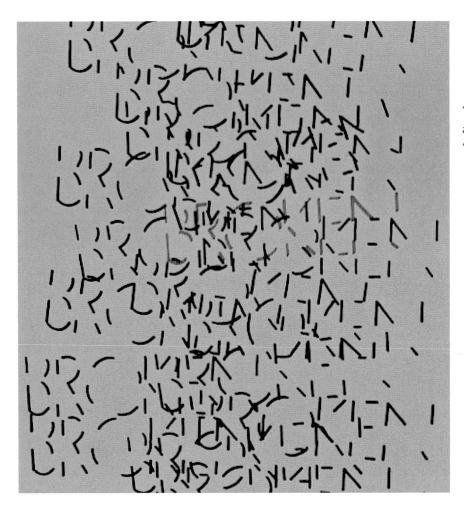

'Broken' by Shane Tan
and the magnificent
'Hairy' by Helen Teo.

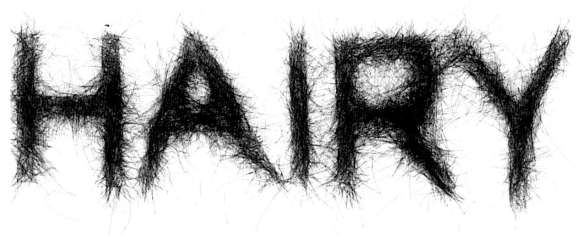

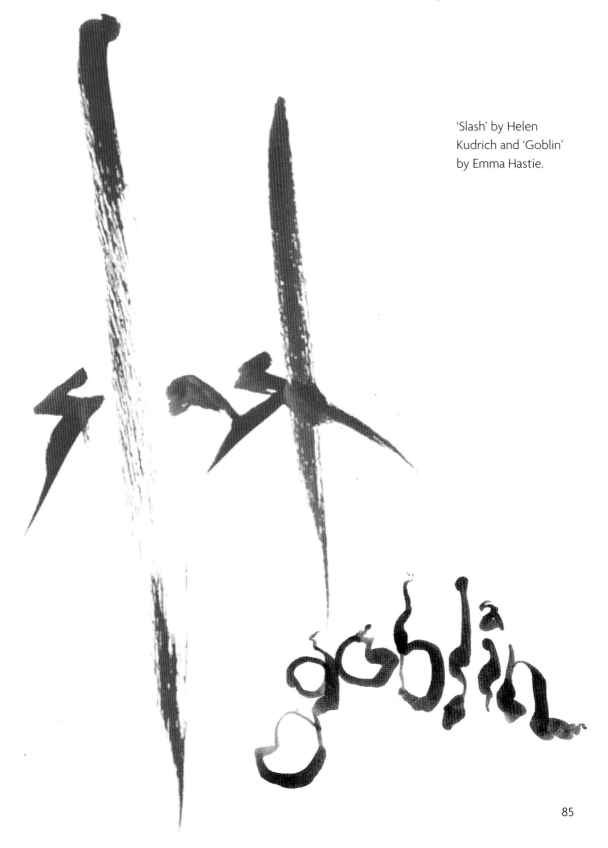

'Slash' by Helen
Kudrich and 'Goblin'
by Emma Hastie.

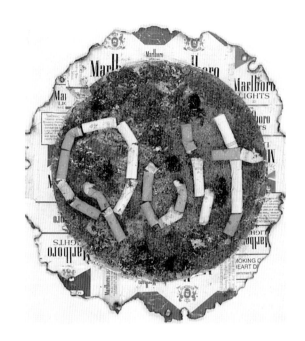

Paul Green-Armytage says that in designing monograms students look closely at the structure of letters and the possible ways that letters can be combined, how far forms can be distorted, stretched, inflated, fragmented and still remain recognisable.

Some of the projects were more light-hearted like Seong Pak Lai's 'Quit Smoking' design and Sally Malone's monogram.

Monograms by Peter Fox, Heather Mundy and Jane Mansfield.

Alphabets by Vaughan James (above) and Nathan Thomas (right).

It is interesting to speculate about the writing implement and technique used here.

Alphabets by Karen Martin (left) and Yuen Kim Cheung (right).

ABCDE
FGHIJ
KLMN
OPQR
STUVW
XYZ

Two very different alphabets by Jud Kieran (left) and Philip Coles (above).

When he introduced the alphabet exercise Paul suggested a distinction between what he called 'writing', 'drawing', 'printing' and 'constructing' letterforms. Written letterforms depend on the writing implement and the way it is manipulated, whether it is with a pen, a brush or a twig. Drawn letterforms can be any shape and be filled in or decorated. There are no examples here of printed forms but typically they could be made as potato prints. Constructed forms varied from cut out collages to letterforms made with wire. Most extraordinary was a word made with liquid chocolate which, unfortunately, was impossible to reproduce.

 The more finished work produced by these students reflected that they had a bit more time to work on their own than those in my short sessions.

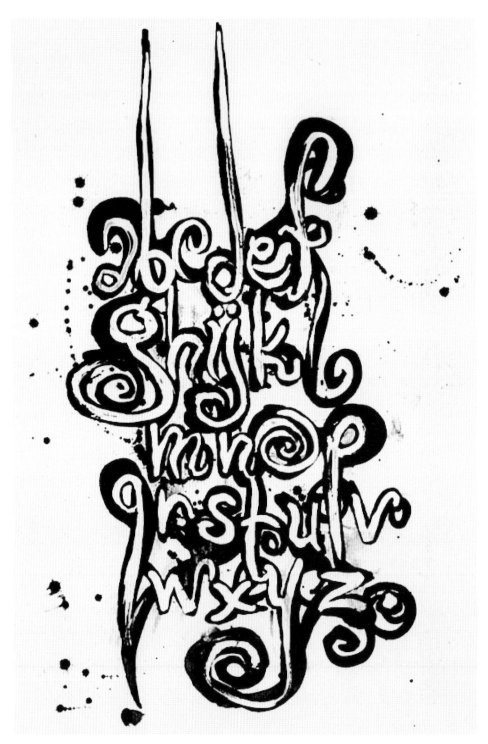

Some alphabets were light-hearted, like this one by Toby Gibson.

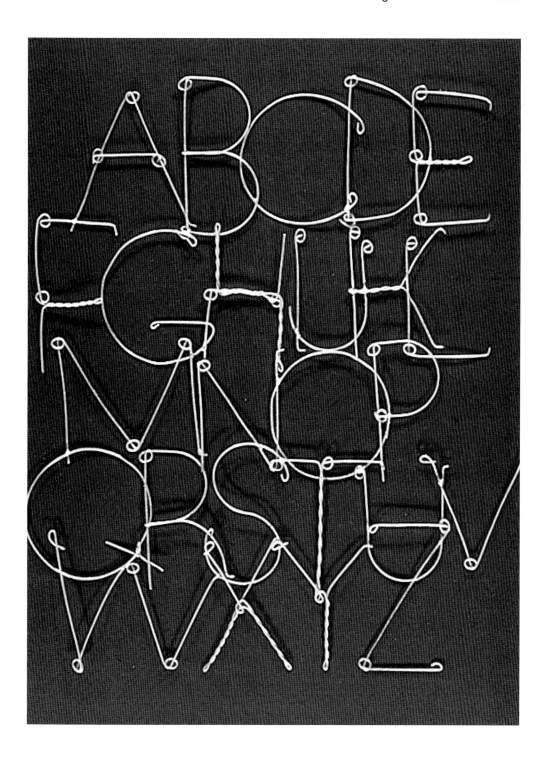

This alphabet, by Ben Zuvela, is made with wire.

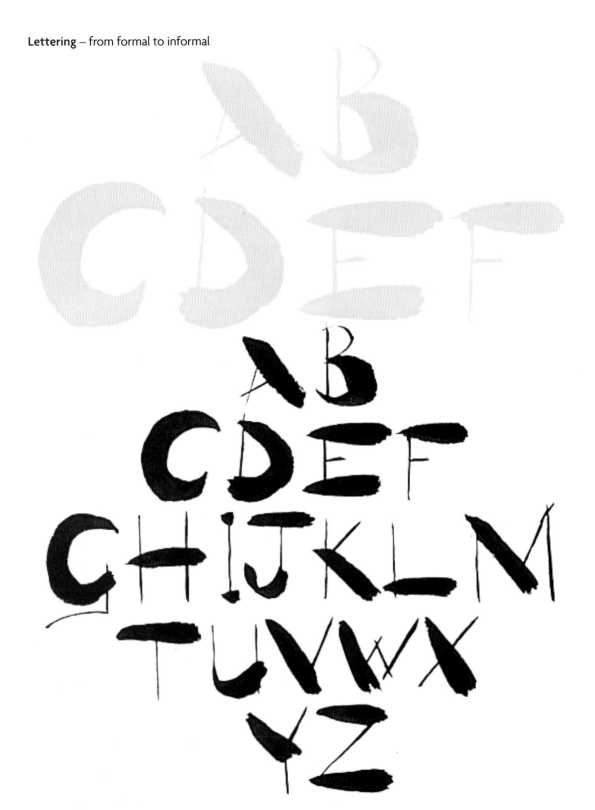

Trenna Dabovich's letters have a strong horizontal emphasis like the exercise on page 58.

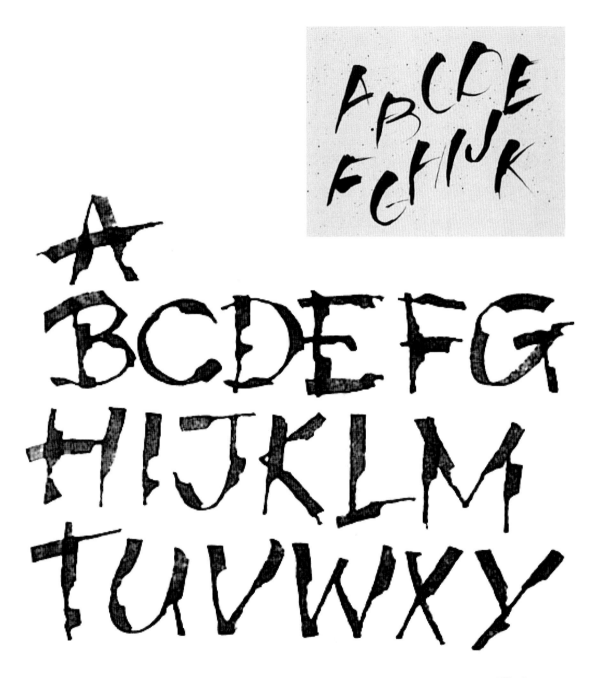

All these alphabets are impressive, particularly considering the students were only in their first year. Not surprisingly, some original ideas such as the part alphabet by Nicki Rae, needed more work. The lower alphabet, by Bima Shaw, was written with a chisel-edged felt marker pen which he twisted as he wrote.

Part 6 **Workshop in Rome**

This part is illustrated with the work produced by students during a weekend workshop in Rome. It shows how rapidly the participants developed personal letterforms and how soon some of them developed their work up to a really useful, almost professional standard. Although the majority of them were graphics students, none of them had much of an idea of lettering. In fact, several were just members of the public.

This section is laid out so that teachers can recreate this progression of exercises with their own students. The first exercise was designed to show how, by using ordinary writing, but with different implements, and in unusual circumstances, anyone can produce interesting letterforms. Joined up lower case (small letters) may be familiar but joined up capital letters are certainly not. So capitals were the starting point.

Using a free-flowing or thick pen the joined capital alphabet must be written a few times, faster and faster. Then each student chooses the most interesting combination of three of four joined letters. Small cardboard frames make this task more effective. It is the ligatures that make the letters personal as much as the slant or the proportion.

It is also interesting to see how the handwriting model taught in Italy has influenced the adult forms. In other countries the effect of italic writing would probably have been more evident.

This workshop was part of a series concerned wirh graphic communication and children. My part was aimed at display letters for children's books. In four short sessions there was no time for the broad edged pen, monograms or patterns. The emphasis had to be on the letterforms alone, although some students found the temptation to use illustrations hard to resist.

Copy the chosen combination several times. This shows that anything that one produces naturally (as different from anything learned by copying a taught model) becomes your own and easy to reproduce. Students can compare their letters, and see how difficult it would be to replicate each others work.

Some people become almost intoxicated with the discovery of the power of their own letters.

The next stage shows how easy it is to reflect the atmosphere of the word in letterforms. This is an unfamiliar concept for adults, although children do it naturally. It can produce spectacular results and you can see how this would lead to lettering for advertising and packaging. These examples were more fun being in two languages with both words treated in the same way.

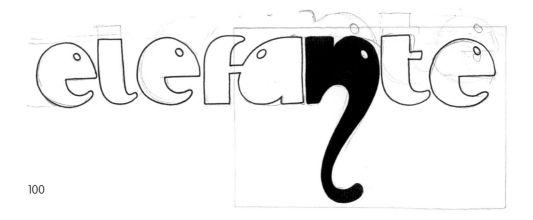

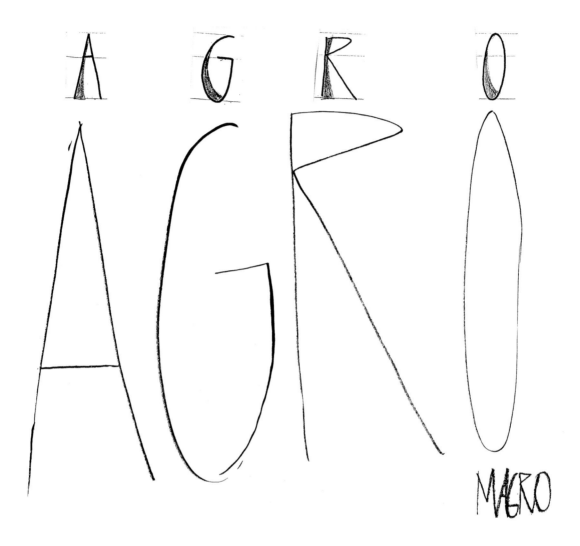

There was not enough time to experiment with monograms or pattern in the way the Australian students had done (see pages 71 to 84), otherwise this would have been the next step.

Descriptive adjectives, however, worked particularly well with this group.

Ed Testa's joined capital letters produced free forms but he soon became interested in a squarer form. This developed into an interest in his own initial **E**. He is now intending to set up his own design business and may use this **E** as his logo.

Incidentally, the row of **z**s discloses his original handwriting model. In this way, he has discovered several styles and feels how easily he could adapt letterforms to suit any purpose. This is a useful skill.

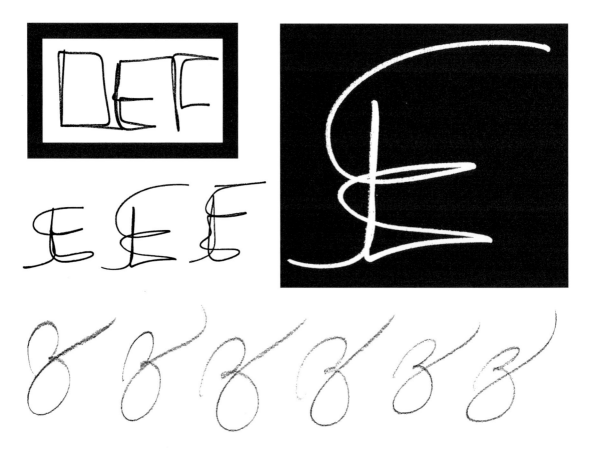

This workshop had a definite object set for it. It was part of a series of four concerned with different aspects of visual communication with children. On the second day students were steered towards producing display letters for use on covers for children's books. Some students designed and illustrated a whole cover, while others attempted the more difficult task of a whole display alphabet

A text typeface was out of the question (both because of lack of time and expertise) but, because it is a subject that is of special interest to me, I gave a presentation on the research that preceded the design of my own typeface for young readers. This would help those who proposed to go further with this kind of work.

This student covered five pages of experiments during the development of her alphabet. It is a promising beginning, but still has some way to go.

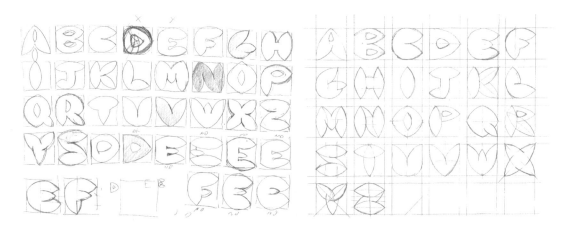

Part of my job was to teach the students how to analyse their own work –
to pick out the good and consistent elements of their letterforms.

You can see how Fabio Vinciguerra improved his letters until the
alphabet began to come together.

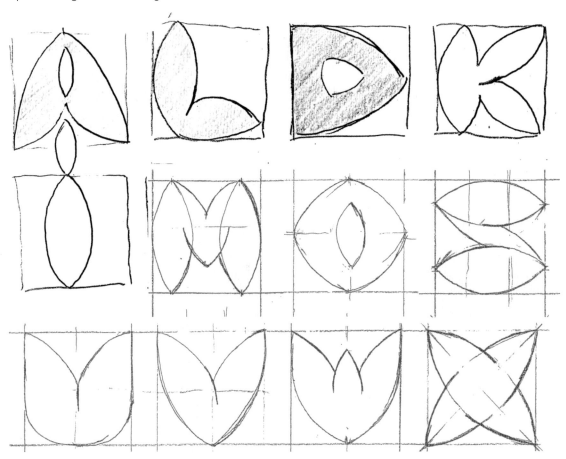

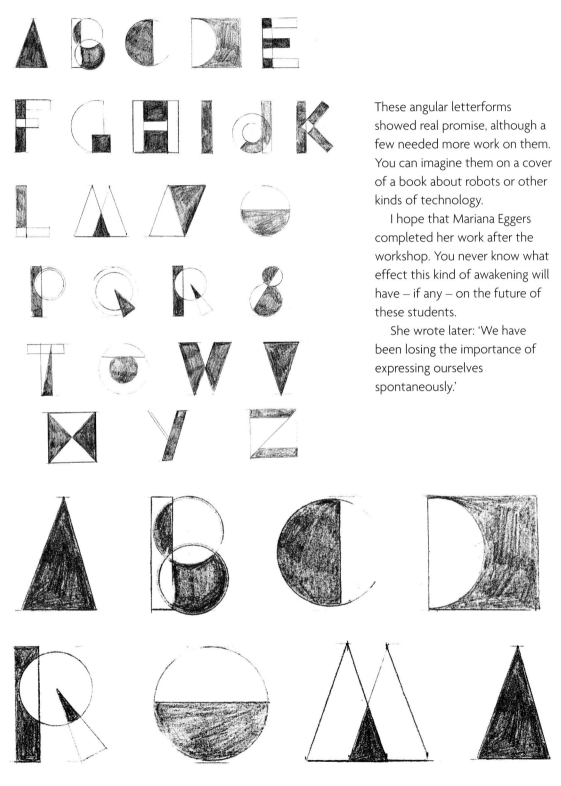

These angular letterforms showed real promise, although a few needed more work on them. You can imagine them on a cover of a book about robots or other kinds of technology.

I hope that Mariana Eggers completed her work after the workshop. You never know what effect this kind of awakening will have – if any – on the future of these students.

She wrote later: 'We have been losing the importance of expressing ourselves spontaneously.'

On the last morning the students were encouraged to scrutinise their many rough experimental pages and produce a large photocopied sheet of what they considered their best work. It was important for them to see how far they had come and to be proud of their achievements.

In a similar workshop in Buenos Aires I had seen an even better idea. There, each student was helped to produce a concertina book, again using their own choice of work. They were shown how to use a cardboard frame to accentuate the most effective small page-sized examples of lettering. This page shows some of the work chosen by Claudia Polizzi.

Camilla Camille

Comelle

Camilla Camilla Camila

LA CAM'LLA

Camilla

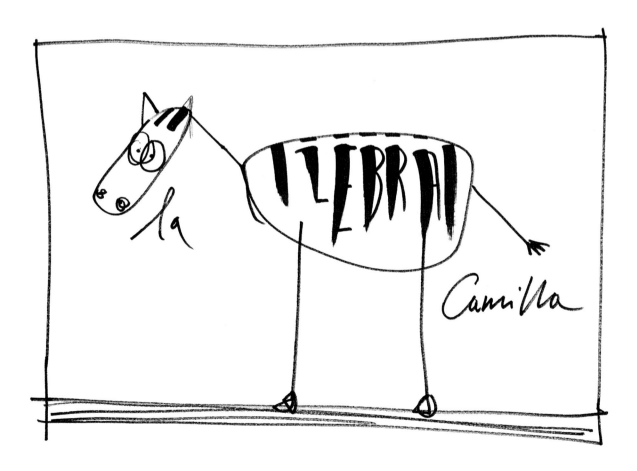

la ZEBRA Camilla

abcdefg

ZEBRA

abcdefghhl

ABCDEFGG

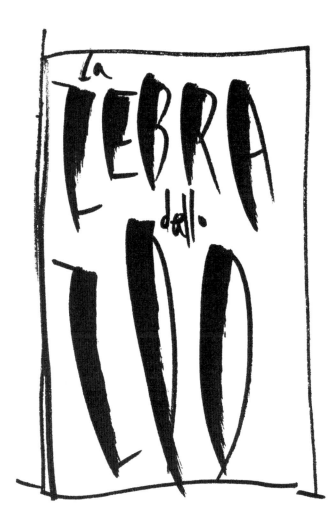

The second spread of Claudia's work shows something any professional would be proud of. It is not easy to produce a consistent alphabet like this at the first attempt.

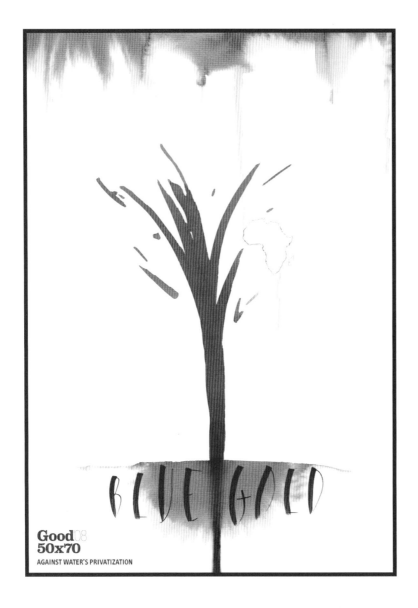

It is not often that I hear how students have used their new found skills. Therefore, it was good to hear that Claudia had immediately used her 'zebra' alphabet on a poster that she designed for a water conservation project.

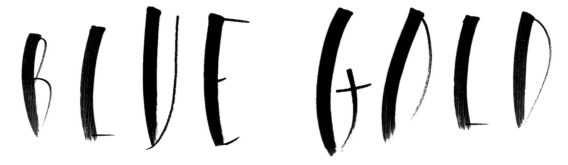

Postscript

It has been an interesting experience to delve into my archives and arrange all this work in chronological order. It traces the way I have changed from the days when I strove to reproduce perfect representations of traditional alphabets and studied and revered classical letters in any form. It reveals how I eventually found great satisfaction in quite a different direction – in encouraging students to find their own way of expressing themselves creatively through letterforms.

It probably reveals much of my character as well. I consider myself as much a designer as a letterer. As such, any work that I have produced had to have a purpose. There has never been time, or inclination for that matter, to produce exhibition pieces as many of today's calligraphers do. I started work in a different age, in different conditions. Many of the techniques that I absorbed as a designer have crept into the way I use letters – and are reflected in what I, consciously or unconsciously, teach anyone who comes my way.

Raising the interest of relative beginners has always interested me more than accepting the sometimes tempting offers to teach more advanced courses. The techniques that I have used avoid the 'copy me' methods that so annoyed me when I was taught other subjects that way at art school. Put that down to a rebellious nature perhaps, but I prefer to bring out the latent talent in individuals, to encourage them to follow their own ideas. You can judge the success from the illustrations in the second half of this book.

It seems to me that by whatever route people have come into letters, whether from historical interest, the designer's point of view or just curiosity, this way of teaching will, with luck, lead people to widen and further their studies in whatever direction their interest or career, permits.

I never intended to continue lettering into old age as I had noticed how less than perfect eyesight and a less steady hand had eventually affected

other people's work. This is just as well as I had a stroke some eleven years ago and my right hand no longer does as it is told. This has not affected my teaching as I seldom demonstrated in front of a class and the computer is here to help. All this enables me to teach occasionally, write and concentrate on type design.

That neatly ends the story. When I look at my first typeface, Sassoon Primary, I cannot fail to recognise the subliminal influence that the Foundational Hand has had on its design. Although, in fact, it was designed after lengthy research into what kind of letters children read most easily.

I often wonder how many of the students that have passed through my hands will go on to produce their own typefaces.

Sassoon® Primary Sassoon® Sans
Condensed Infant Sans Sloped
Dotted Italic Book Medium
Tracker Book Italic
Montessori Regular
Bold Dotted Tracker
Sassoon® Joining Script

Some of the variations that developed from the original Sassoon Primary typeface.